it from most other collections, which often, within their own specialities, depend very much on what is available.

The success of a paper company depends on the long-term development of forests and their environment. Issues of conservation and commitment to future generations are basic to such an industry if it is to last. 1984 marked the one hundredth anniversary of the Gilman Paper Company, and they chose to create a book using the finest paper which would take the collection out to a wider audience, and would reproduce, as faithfully as modern skills and technology can, the characteristics of the originals. The fact that they decided to concentrate exclusively on their photographic collection is not only an indication of its present importance within the Gilman Collection, and of their commitment to the conservation of this fugitive medium, but also a tribute to photography itself.

Richard Benson's fine prints reproduce those most important characteristics normally absent from reproductions in books: the surface texture, the variations in colouration within single prints, the idiosyncracies and individual qualities of each process. From the careful selection and sequencing of images from the earliest photographs to the recent, and the fine design and typography, to the shape, size and weight, every aspect of the book as an artwork in its own right has been considered. Bruce Bernard's idea to use a selection of the prints to make two exhibitions was inspired by one of the earliest rationales for the book, to make the photographs available to a wider public, through Benson's unique printing techniques. Through these exhibitions an even wider public may understand the subtleties and variety of photography over the last one hundred and fifty years.

ACKNOWLEDGEMENTS

This is the second of two exhibitions drawn from the book "Photographs from the Collection of the Gilman Paper Company" by Pierre Apraxine, with plates by Richard Benson, published in a limited edition by White Oak Press in 1984.

The exhibitions were devised and selected by Bruce Bernard, who has also written the introductory essays and captions. We are grateful to him for bringing to our attention the exceptional quality of the plates in this book and for suggesting that we circulate a selection of them in exhibition form. We also thank Pierre Apraxine for his interest and useful advice and Valerie Lloyd for an informative account of the importance of the Gilman Paper Company's Collection. The technical note by Richard Benson is reprinted from the book.

Joanna Drew
Director of Exhibitions

3

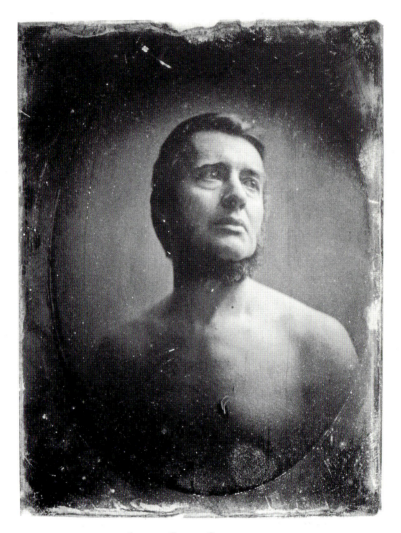

5 ALBERT SANDS SOUTHWORTH
American, 1811-1894
Self Portrait, c.1848
Daguerreotype, hand-coloured

Southworth and Josiah Johnson Hawes are the most famous of American
daguerreotypists. They were devoted to the technical and artistic improvement of the
process and recorded many of the most eminent Americans of their day.
This idealised portrait, which may have been taken by Hawes, is a remarkable image
and exceptional in its aim to emulate a classical bust.

4

the Art that threatened Art

BRUCE BERNARD

THE main pleasure that the contemplation of the first fifty years of photography offers us is the taste of first the unripe and then the earliest mature fruits of one of the most momentous and culturally radical of all modern inventions before its products became both ubiquitous and mass-produced. Looking at the more "primitive" does not make us wish that Fox Talbot had achieved the technical excellence of the Bisson brothers or Irving Penn any more than we want to find the scope and virtuosity of Michelangelo in Duccio or Giotto. We could surely not fully enjoy or understand any art or science without comprehending to some extent the history of its development, and in the case of art we may sometimes find ourselves valuing the child at least as much as the grown man. To some the first twelve or fifteen years of the photograph will always provide the most pleasure, just as the Italian Primitive painters can seem to others far preferable to the giants of two hundred years later.

The special characteristic of the earliest photography as opposed to later work and to painting, is that it makes us feel acutely that nature itself was largely responsible for forming the images, making the person directing the camera seem more midwife than creator or even craftsman. This seems particularly true of photographs not depicting human beings, who themselves, through their necessarily personal response to the camera in the days of very long exposures, became important agents of the image's creation. Human control had to be asserted and human beings became the most important subject. A count of subject matter here shows that photographs of people far outnumber any other single subject. This was surely human nature and however beautiful the work of Le Secq, Thomas Keith, Robert Macpherson, Marville and Carleton Watkins is, it is to ourselves that most of us want to be revealed in likenesses of people of all kinds and times – family, friends, strangers, enemies and the great.

There is one of William Henry Fox Talbot's early calotypes here (no. 2) and it is of a rather fascinating pinkish brown with a trace of blue, a tint which must have looked a little different from any colour seen before in any kind of print. Fox Talbot achieved many colours by chemical chance in

his early years as the great pioneer of negative-positive photography. Some of them seem beautiful and entirely apposite and others less so. It is worth remembering that he was not trying to make the black and white print that is inseparable from monochrome as we know it today. Neither did the "sepia" which we associate with the whole of 19th-century photography seem particularly desirable to him. He found that he could not obtain a uniform tint because of chemical impurities and inconsistencies in the paper he used and commented, "These tints might undoubtedly be brought nearer to uniformity if any great advantage appeared likely to result, but as the process presents us spontaneously with a variety of shades and colour it was thought best to admit whatever seemed pleasing to the eye."

The range of colour in 19th-century photographs certainly becomes more limited and consistent with time, but there are still many people who are unaware of the variety of hue, from the blinding bright blue of the cyanotype to the dense black of some carbon prints, which a 19th-century photographer could eventually choose from. Even within the more limited range of reddish, blackish and yellowish browns, there is a variety and vitality of colour which the uniform tints that until recently were always used for economic reasons by publishers to suggest or masquerade as faithful to the originals, subtly but deadeningly falsify. The beauty of the daguerreotype has also been hidden from most people until recently, though even and perhaps especially the untinted survivors can show how beautiful minimal colour can be (see no. 1). The high quality of reproductions shown here are an advantage in their case. In the original the highly reflective, indeed mirror-like surface offers an awkwardly elusive image that needs exact adjustment of the plate to the sources of light.

Photographs though soon became more than sensitively supervised replications of scenes in various colours. They turned out to be, in varying degrees, positive expressions of the diverse temperaments of those who took them. When Niepce, Daguerre, Bayard and Talbot had their first experimental successes little did they realise that they were presenting human beings with yet another way of expressing their insistent or more modest individualities, though Bayard and Talbot soon found themselves doing so willy-nilly. We can appreciate Nadar as an urbane, intelligent and basically unpretentious man long before we read a word about him. Julia Margaret Cameron immediately conveys her passionate nature in her often aggressively reverential confrontations with her sitters, and we sense in Carleton Watkins a powerful if phlegmatic devotion to his impersonal subject matter which somehow distinguishes him from other great pho-

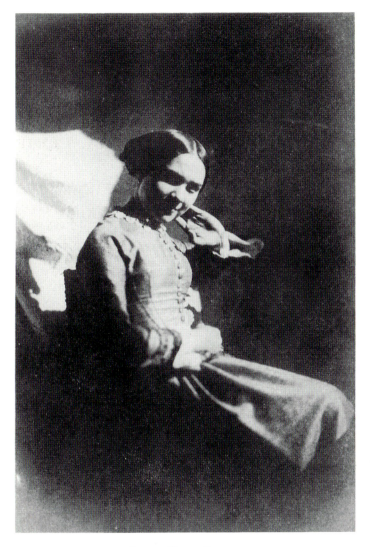

8 LOUIS-REMY ROBERT
French, 1811–1882
Henriette Robert c.1850
Salt print from paper negative

This bold chiaraoscuro view of a lively girl is remarkable for its abrupt tonal
transitions in the face and hand which would not have been so marked to
Robert's naked eye.

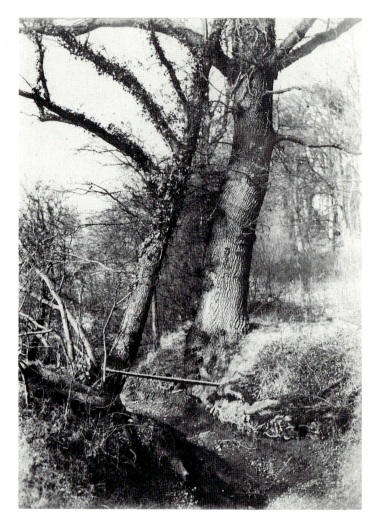

10 THOMAS KEITH
Scottish, 1827-1895
Trees, 1854
Salt print from waxed-paper negative

Keith was a surgeon and gynaecologist and a photographer for only five years. He was first stimulated by the work of Hill and Adamson who also lived in Edinburgh. Although he mostly photographed views of the city he occasionally tackled landscape as he does very successfully here. It is an uncompromising and far from picturesque look at the random intricacies of branch and bark – as good as anything of its kind.

tographers of almost identical scenes.

There have been moralists of a political bent who might have imposed a philosophical discipline on photography could they have done so, but the enjoyment of the art is deeply amoral, however good it is at conveying some of the best human values, particularly ordinary decency. But we want more than that. We need to see the world vicariously through many pairs of eyes whose interest is never as detached as it may sometimes seem and whose subjectivity is as inescapable as the painter's. Zola's definition of art as "nature seen through a temperament" applies as much to photographers as to them. This exhibition should show how rapidly this became evident. It is even after all an expression of temperament to take great pains over photographing an eclipse of the sun or of Boston on a wet-collodion plate from a balloon.

Some of the photographs here have never been surpassed. However many great portraits have been taken since, none can claim to outclass Robert Howlett's Brunel or Cameron's Sir John Herschel. I never hope to see a mountaineering picture more beautiful than the one taken on Mont Blanc by the two Bissons. Timothy O'Sullivan's "Ancient Ruins, Canyon de Chelle" will always be exemplary, Sarony's Oscar Wilde could not have been better and Gustave le Gray's calm amplitude will never be surpassed. In comparison with the early masters, present-day photography of architecture and archaeological sites has surely suffered through technical sophistication and the outlook of glossy magazines and tourist brochures. Serious photography's reaction against the picturesque banality of current landscape in colour has been to cultivate a rather over-earnest aesthetic of black and white. For most, landscape in photographs has become largely the background in car advertisements. It is only in photo reportage that there has been unquestionable progress and that seems to have ground to a halt through the absence of magazines that value it sufficiently.

Not long after the last picture in this collection was taken the birth of the modern snapshot took place and newspapers and magazines soon found a way of reproducing them. True colour was then achieved with the Autochrome and the struggle of the very consciously artistic pictorialists entered its last and most fertile phase. But many beautiful processes soon lost public credibility and the large plate camera retired to the High Street portrait studio (though there are now plentiful signs of its re-emergence). The Kodak and its roll of film had transformed everything.

What you see in this exhibition is not mocked. It embodies a sense of things well seen and magically preserved that the great leaps in technology including the moving picture have not nullified or subsumed. Photo-

graphs are still taken that seem wonderfully alive but I feel that the art – and there is no doubt that it is one – needs to regain something it has largely lost: a kind of patient gravity that is far from heavy and that can be experienced in many of the pictures here.

The reproductions of photographs exhibited here were commissioned and published by the Gilman Paper Co. of New York which, under the curatorship of Pierre Apraxine, has over only twelve years or so built up one of the finest of all collections of the photograph, the examples on show representing only a very small fraction of its 19th century holdings. Four factors dominate Apraxine's choices. The image itself, its quality as a photograph, its fineness and state of preservation as a print and its role, when it coincides with one or more of these as a vehicle for the enhancement of general historical understanding.

So this is an exhibition about the photographic print as well as about the art of photography and it also tells us what has become possible in the field of mechanical reproduction when it is made subject to skilled and sensitive human manipulation. Apart from the fact that reproduction of such fidelity enables wide participation in something very close indeed to the special pleasure of looking at original prints, it also allows their virtues to be shown in bright light, which would otherwise cause irreparable fading.

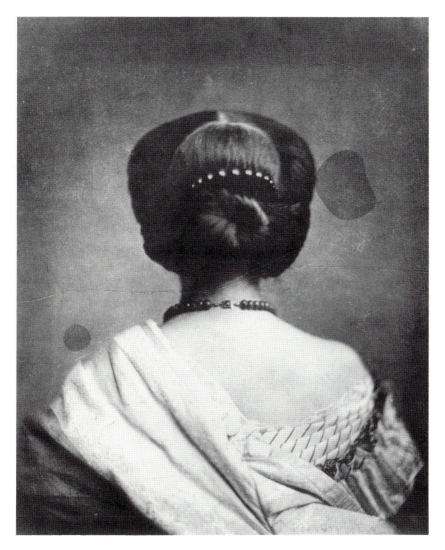

31 VISCOUNT ONESIPE-GONSALVE AGUADO DE LAS MARISMAS (COUNT AGUADO)
French, 1831-1893
Woman from the Back c.1862
Waxed salt print from dry collodion negative

Another aristocrat photographer who was one of the first to make enlargements from
negatives and who with his brother made several witty *tableaux vivants* depicting the
amusements of the rich.

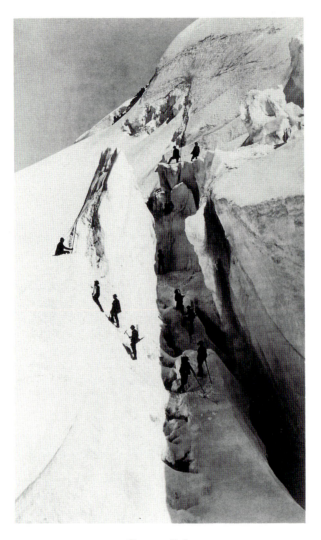

18 BISSON FRÈRES
The Ascent of Mont Blanc, 1861
Albumen print from wet collodion negative

The brothers Bisson eventually became the pioneers of mountain photography, and as
this masterpiece shows, they have never been surpassed. There is a curious feeling of
suspended animation as even in such strong light it seems to have been necessary to
ask the climbers not to move. The composition of the figures, surely partly due to
luck, seems as perfect as it could be.

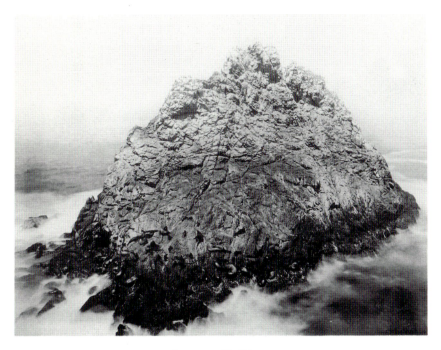

44 CARLTON E. WATKINS
American, 1829-1916
Sugar Loaf Islands, Farallons, c.1868-69
Mammoth-plate albumen print from wet collodion negative

Watkins is now rightly considered to be unsurpassed as a photographer of the
landscape of California and this wonderful print clearly demonstrates his
preoccupation with mass. The surf pounding on the rock and the squirming seals, the
sharpness of the rock in contrast to the sea blurred by movement make it a stunning if
not entirely comfortable image.

AFTERWORD

RICHARD BENSON

The following account of the production of the plates is reprinted with minor amendments from the book "Photographs from the Collection of the Gilman Paper Company" with the kind permission of the author

THE PICTURES in this exhibition are printed by photo-offset lithography, that most common and modern of all inkprinting techniques. This process was chosen not only for its versatility but also because it has no overpowering character of its own; this has allowed the plates to take on the appearance and presence of the original photographs to a greater degree than would be otherwise possible. All the printing has been done on a Meihle twenty-nine-inch, single-color offset press, a massive model built in 1964. The halftone negatives, with the exception of those for the nine plates done in process color, have all been made directly from the original prints using a Kodak three-hundred-line magenta halftone screen. These negatives have been stripped and plated by Thomas Palmer, who has worked on the press with me and whose help has been invaluable throughout all stages of this project. The papers chosen, Warren Lustro Offset Enamel and Mohawk Superfine Eggshell, are what we feel to be the finest available for modern lithography. Photographs from the past vary widely in their surfaces, and by printing our plates on these papers, one coated and the other not, using both gloss and matte inks, we have been able to capture some of this variation.

The chief limitations of photo-offset lithography are that it prints a thin layer of ink and that it prints in one tone only. Thus a value of colour may be printed in a flat even tone, but it will lack intensity and variation owing to the thinness of the ink transfer. Two techniques have evolved to overcome these problems. The first is the use of multiple impressions to build up a strong ink layer: the modern offset press can perfectly superimpose two or more images from different printing plates, which permits extraordinary variations in weight and color. The second technique is to create tonal variation by the use of the halftone screen. This tool, used in the making of the negatives from which the printing plates derive, breaks up the smooth tonal variations of the work being reproduced into fine, regularly spaced dots of varying size. This dot pattern modulates the flat tone of the lithographic process so that it can, however imperfectly, emulate the tones of the photograph.

For years I have loved the broad and smooth areas of color that exist in posters printed by stone lithography, and in working with the halftone screen to reproduce photographs, I have struggled to apply this inherently lithographic quality to the work of the stone's descendant, the modern offset press. In this book an attempt has been made to do this. Rather than using the halftone screen to portray the full photographic scale from light to dark, it is used instead to carry the tonal transition from one value of flat color to another. In each reproduction there is at least one solid layer of ink, with no halftone dot, running through most of the tones of the picture. This layer lends a density and structure to the plates not usually associated with photo-offset lithography.

All of this is completely unlike the modern methods of color printing – the practice